Dedication

This book is dedicated to all those smart people that can't help but shake their heads at the state of the world today.

Further, to two gentlemen who have inspired me greatly through their works, although I never had the pleasure of meeting them in person, Christopher Hitchens and George Carlin. It takes courage to stand up in this world and speak your mind, to go against the mainstream and to express unpopular opinions, and these guys had that in spades! George, through the magic of videos and books, I still get to enjoy your insightful and hilarious social commentary. You had a unique way of making us laugh at ourselves and the messes we ultimately created. And Christopher, well, your legacy of erudite wordsmithing lives on. No one could call bullshit on a system, a politician or anything else for that matter in such a clever and sophisticated way, kudos.

Introduction

As a young man, I never watched the news; I never followed politics. I was generally, blissfully unaware of anything that was going on in the world, and more than that, I really didn't care. If it didn't have a direct and immediate impact on me personally, well, frankly, it just didn't exist. I was happy in my state of blissful ignorance.

Fast forward a few years, and that blissfully ignorant young man began to grow up, as we all do, and began to take notice of the world outside of his own bubble. Not in any real deep or meaningful way, but enough to watch a bit of news and follow politics, at least on a superficial level, just enough to parrot what I was hearing around me as my own thoughts and opinions. And really, I thought they were. I was the best little sheep you could ever meet, following the herd whichever way the wind took it. I mean, what else was I to do? I wasn't an educated man on these matters; best to leave the thinking to those more qualified, right?

However, as the years passed and forty came and went, I began to expand my horizons, to read, to study, to talk to people, a wide variety of people. I was encouraged to look at the headlines and listen to the soundbites with a critical eye and ear. I was both shocked and horrified at what I learned. All those things I had believed, all those opinions, you know the ones other people had that I just adopted as my own without much thought, were, for the most part, complete and utter garbage. Some of them were even more than that, they were out and out lies that anyone with even a rudimentary understanding of how politics or the Constitution works would spot in a heartbeat!

And as time went on and I became more and more aware, I noticed things didn't seem to get any better. In fact, they seemed to get worse, until what I discovered was that we had devolved into a society of political correctness, where free expression has been replaced with sanctions, both real and imagined for wrong think and civil, lively debate has been replaced by mean – spirited school yard taunts. The news isn't the news anymore. Remember journalism? The 5 W's, who, what, when, where and why, the facts and just the facts. Well, they seem to have been replaced by "info-tainment" programs where facts are lightly sprinkled over opinion and political leanings. I could go on and on here, but you get the idea.

Of course, to process this, and to perhaps purge my frustrations in a constructive fashion, I turned to the only thing I knew, painting. I found, to my surprise, that the boy who once abhorred anything political; the boy who refused to watch the news, not only noticed world events and social commentary seeping into his work, but he was compelled somehow to speak his mind through his paint.

These works can be divided into four categories, and are, for the purposes of this book, Religion, Politics, Not So Free Speech and General Societal Trends. They're not perfectly neat categories, often they overlap. Just like life, nothing's ever neat or tidy.

Many of the pieces are humourous, others, a bit disturbing or dark, and the opinions expressed may not be ones you hold or even are comfortable with. That's fine, they're not your paintings and they're not your opinions or observations, they're mine; but if they make you chuckle or better yet, think, you know, use that noggin to actually ponder, to critically evaluate, to consider that there are always at least two sides to every story, then I've done what I set out to do.

RELIGION

There's no doubt that spirituality, or faith, is a large part of the lives of countless people around the world and I don't dispute the fact that it adds something positive to their existence. I'm sure it provides them with comfort and purpose, and I wouldn't and don't wish to take that away from anyone. In fact, there have been times in my life when I have been quite spiritual, maybe even, dare I say, religious.

That being said, I draw a distinction between spirituality and the organized religion I refer to in this section. To have a sense of spirituality or faith is one thing, but to follow the edicts of man-made systems of belief, to follow rules and commandments made by men who claim to be the representatives of The Almighty here on Earth, well, that seems another thing altogether. And each of these men proclaim that they, and they alone are in possession of the truth and their book is the one and only holy word. How can they all be right?

From where I stand, organized religion, as I just described it, has led us as a people to more judgment, hatred, ignorance and violence than anything else ever has. One doesn't have to go too far back in history to find support for my assertion, there's the cruel forced conversion of our Aboriginal peoples, the violent and often bloody Protestant – Catholic divide in Northern Ireland, the molestation of children by priests, suicide bombers, just to name a few and I've barely scratched the surface. In fact, I've only gone back about fifty years in a history that spans thousands. I think one of my favourite authors, the late Christopher Hitchens, had it right in the parenthetical title to his book, God is Not Great, religion really does poison everything.

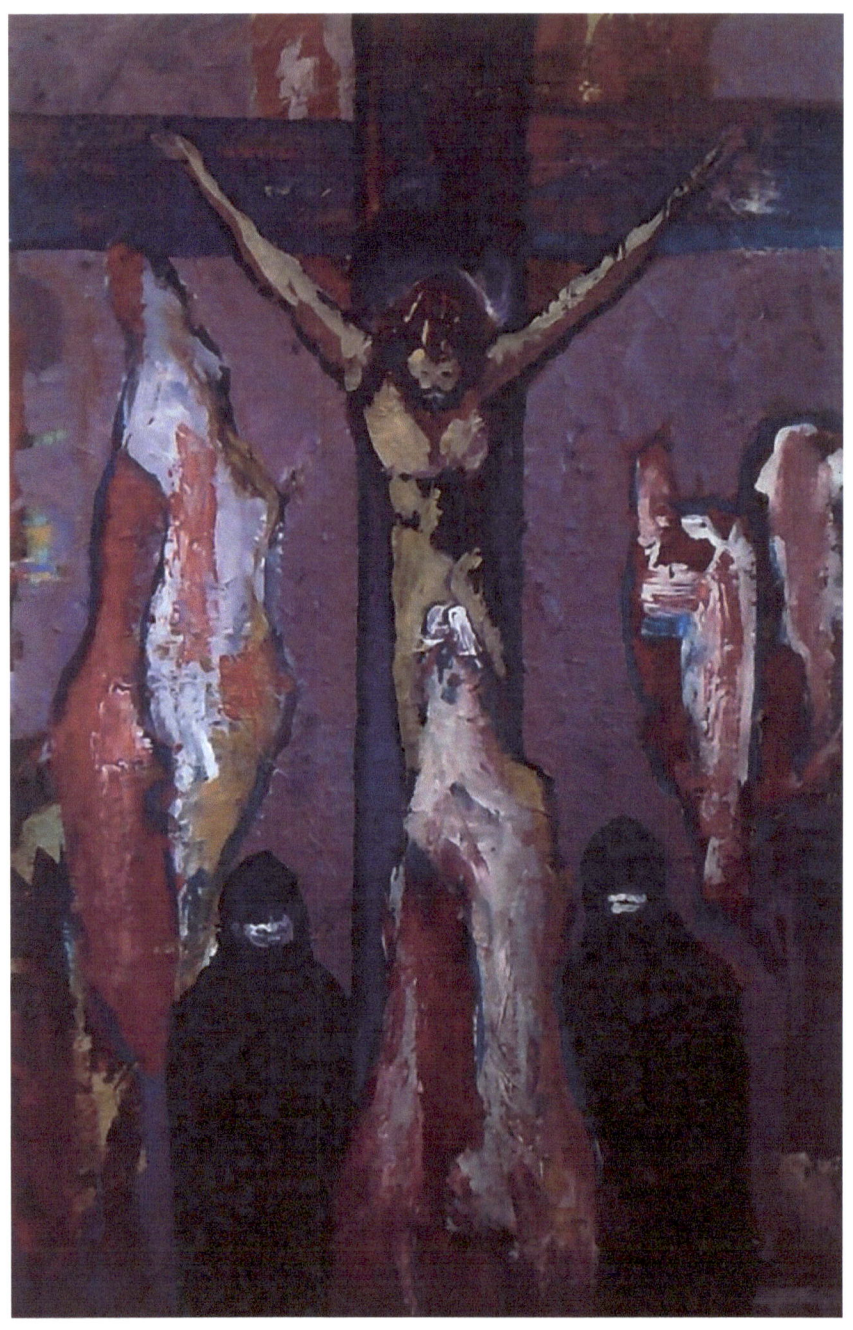

MEAT

This continues to be one of my favourite "protest pieces" and in my opinion, one of the most powerful. As you can see, there are some elements of the work that were inspired by one of my favourite artists, Francis Bacon.

Although the image may appear, at first glance, to be quite complex, the message is almost stupidly simple. Regardless of what religion one adheres to, regardless of the rhetoric, the wars over land, the suicide bombings, the condemning to hell of those who don't share in a particular conception of an all-powerful deity, we're all the same underneath.

It doesn't matter if you're Protestant, Catholic, Muslim, Jewish, Hindu, agnostic or an Atheist, if your heart stops beating, and you stop breathing for long enough, you'll die. You may differ on where you think your soul ends up, but you're still dead, as far as the physical body goes. If you cut yourself, you will bleed, the blood will be red regardless of how, if and to whom you pray. In essence, when you strip us down to the very basics, the very biology we all share; take away colour, nationality, religion, we're all pretty much meat, hence the name of the painting. If you can find me a religion that has consistently and continues to teach, respect and truly practice that principle, let me know, I might just be interested.

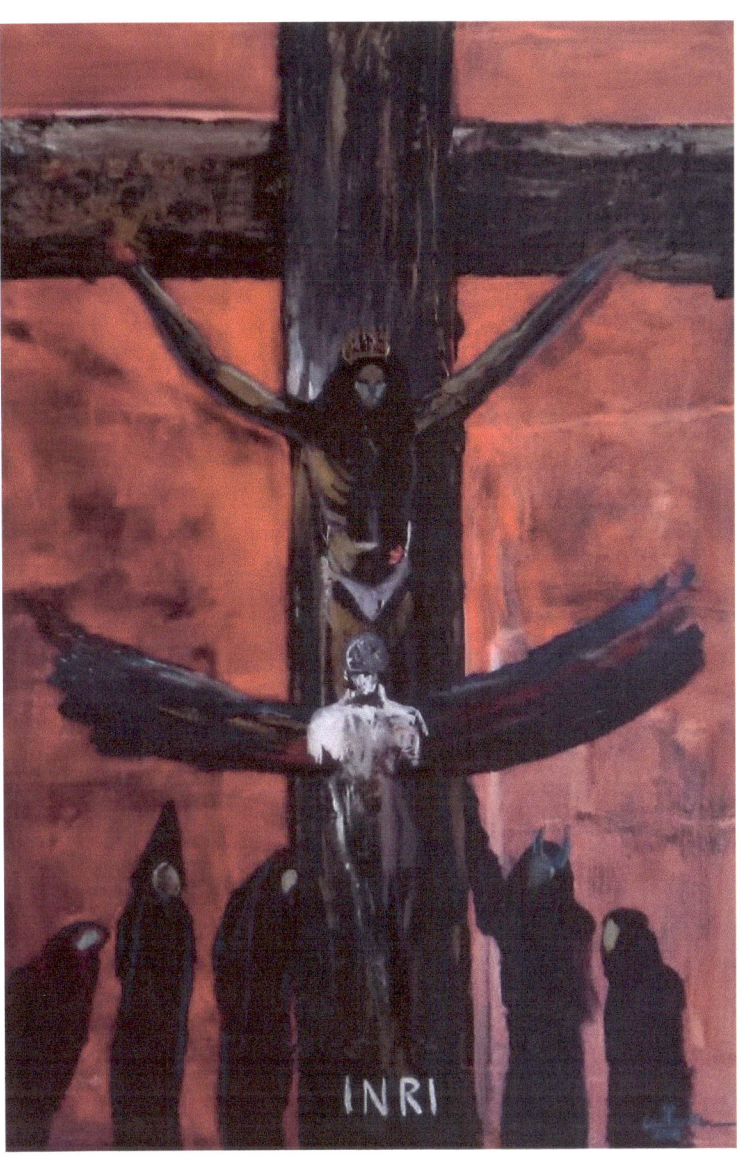

FANTASY OF A LAMB

This one is a more recent piece, 2018. As you can probably see, the frustration with organized religion grew. In this painting you again see my representation of various mainstream and not so mainstream faiths. Obviously, Christianity is there, as well as Islam, perhaps Wicca or Paganism, there looks like there might be a devil there and an angel. All sorts of people, all sorts of beliefs.

I grew up in small town eastern Canada, and where I lived everyone was a Christian, either Baptist or Catholic and no one really cared, but it was pretty clear that my family was certain we, as Baptists, followed the right "god" in the only correct way to do so. I didn't really meet anyone of any other faith. Let's put it this way, to me, back then, Penticostals were somewhat exotic and fascinating.

Then, as I grew up and travelled and moved around, I began to meet all sorts of people, Jews, Muslims, Pagans, those who profess to be witches, Satanists, Atheists and those who didn't quite know. And for the most part, they all followed a completely different, yet, identical rule book, don't murder, don't lie if you can help it, don't take stuff that doesn't belong to you, and generally don't be a jerk. It got me thinking, if there's only one supposed god, why did he create so many different rule books? Hmmm.

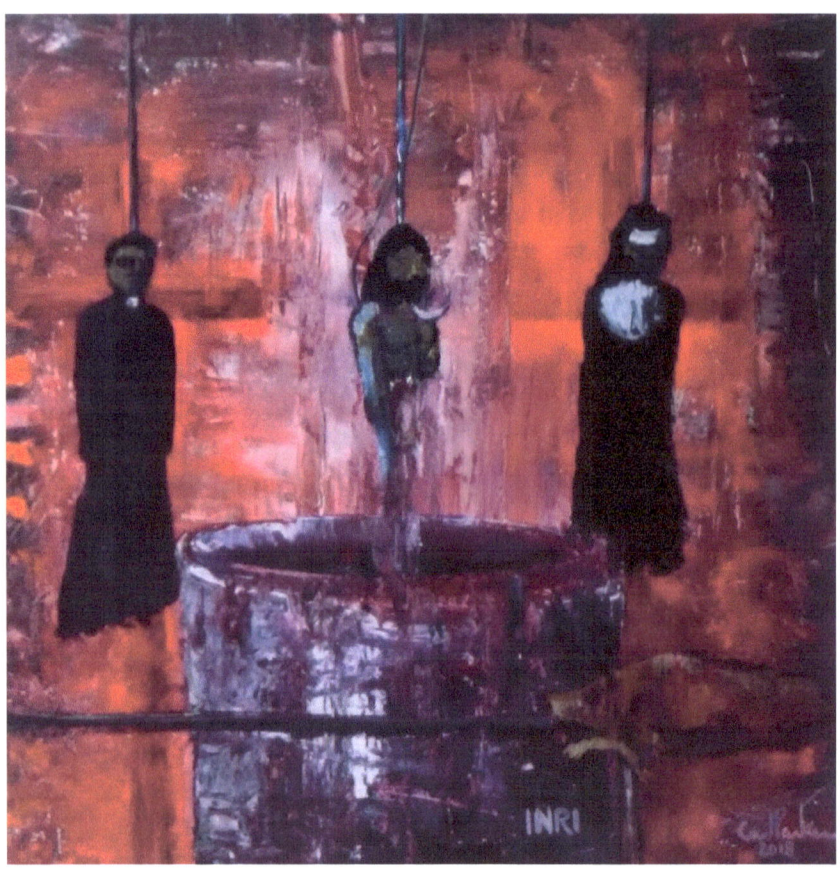

MEAT VARIETIES

One of the most frustrating things to endure as an artist is when people just don't "get it." You create a piece that you are so proud of, that you think is impactful and that just spells it all out, and no one responds. What do you do? Well, I guess you turn up the heat, and that's what I did here.

If they didn't get the message with Meat, maybe the fact that organized religion and its various dictates are causing us to destroy each other, and in turn, ourselves, won't be lost on the viewer if I place some religious figures over a nice hot vat of boiling oil. If you don't get my point by now, well, I think you're just not trying hard enough.

.

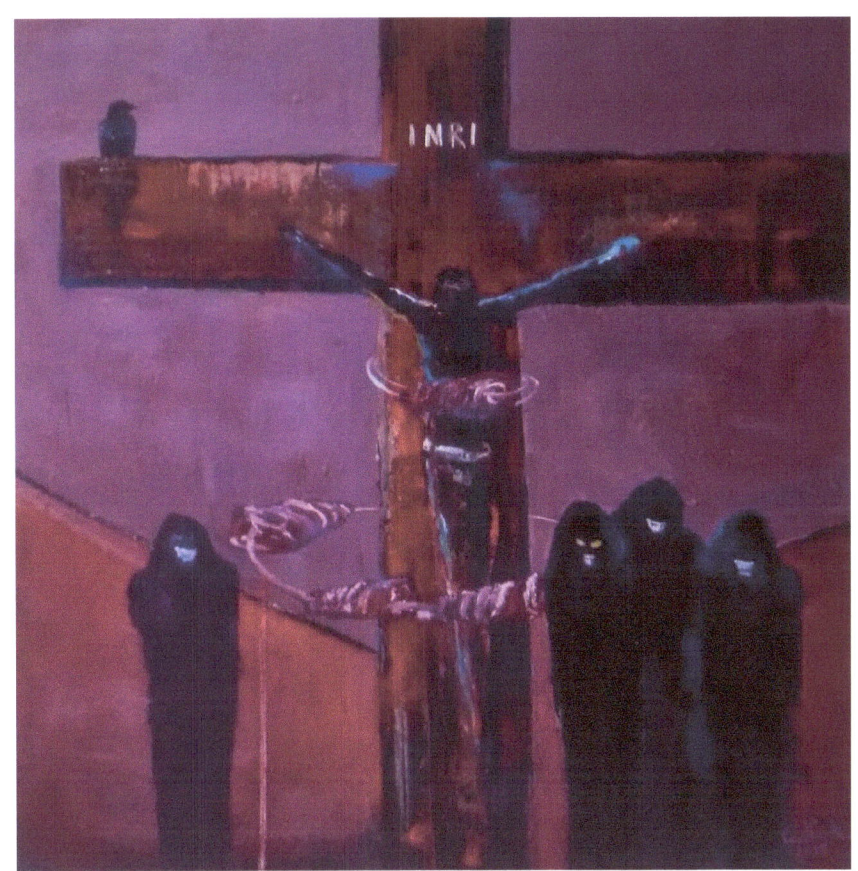

TIME FOR A BBQ

Remember the good old-fashioned neighbourhood bbq? Sometimes they called it a block party. Everyone on the street would come, and they'd bring a dish; someone would bring potato salad, another would bring some hot dogs, someone else would bring some drinks. And you'd eat and chat and laugh, even if you weren't all that friendly with some of them. For that one day, you could put petty disagreements aside for the sake of the greater good. Yeah, Joe might be a bit of a jerk, but once he's used to you, he's not half bad, and besides, his wife makes the best brownies.

Well, that's what this painting is all about. Following up on the meat theme, I began to wonder what would happen if we could just all just sit down, all of us, all religions, each of us, bring our favourite dish from our respective cultures, and have a meal and a chat. Just set aside that stubborn "who's right and who's wrong" and enjoy some good food and just listen to each other, and then respond, respectfully. Forget the rhetoric, and just sit together as people and discover the things that unite us rather than the things that set us apart. I guarantee you there are people doing this on a small scale right now. I, myself, have had occasion to break bread at a table with an Atheist, a Jew, a Muslim and a Catholic, and you know what happened? We ate, we talked, we laughed.

Why can't we do it on a larger scale? Could it be that those in power don't want their flocks of followers exposed to such radical ideas as "those other guys really aren't so bad?"

Would the tithings and collection plates run dry if a common enemy to unite against suddenly ceased to exist? Would the congregations of the faithful begin demanding their respective leaders work to seek peaceful compromise rather than rigid and often violent adherence to ancient feuds? Would that be so bad? Think about it, who is losing out now, and who has the most to lose if it changes?

POLITICS

Where do I even start with this one? As I began to follow politics, I could see and somewhat understand how people could get into heated debates, how they could dig their heels in, refusing to accept anything that contradicted their "side's" views. I'll even admit to feeling a certain sense of pride and triumph when my "guy" or "gal" won a given election, safe and happy in the knowledge that more people agreed with my way of thinking than didn't. I was right, those other people were wrong. We sure love to be right, don't we?

Negative election ads have been a thing for years, one party calling out the other party's, or candidate's perceived weaknesses and faults. It's unpleasant, and maybe even demeaning to the very idea of seeking an office in which one aims to represent the public. But in recent years, this negativity has increased by epic proportions. Mean spiritedness, name calling, and memetic warfare have somehow become the order of the day. Preying on the actual and perceived weaknesses of an opponent have become not only commonplace, but a sign of strength and might, rather than weakness. And before you get up on your high horse, pointing fingers, no one party, politician or movement has cornered the market on this trend. When a Republican makes fun of Hillary's looks, it's mean, unwarranted and has nothing to do with any real issue that could possibly exist. But, when a Democrat pokes fun at the current president's appearance, his large frame, orange hue, whatever, it's not the virtuous condemnation you think it is either. And let's face it, as a Canadian, the looks of our politicians really haven't been an issue until recently. I mean, our leaders have never been elected for their looks. Granted they tell me Stephen Harper had pretty eyes, and our current Prime Minister, Justin Trudeau, undoubtedly created quite a stir with his boyish good looks. But here's the thing, pretty eyes, boyish good looks or nice hair can't balance a federal budget or pay down a deficit. Ability has never been something you can see in a person's looks. We need to look deeper, what about qualifications, character (proven character, not allegations and backroom whispers), track record, you know, actual qualifications for the job?

 If I recall my reading correctly, the whole idea of democracy, as contemplated by the ancient Greeks, was for the public to choose those people who were the most qualified to represent them to public office to do just that. Not the prettiest, not the best looking, not the one your favourite news anchor likes best, the most qualified to do the job. We've forgotten that.

And then for either side to go further to comment on the wives or children of those who are brave enough to throw their hat into the ring and say, "I'm here, and I want to serve," well, that's just cheap and frankly, to me, evil.

But the real kick in the teeth here is that this mean, nasty vitriolic hurling of insults isn't limited to the politicians; it has found its way into the lives of us every day regular people. Now, when someone supports a candidate, party or position we don't like, we label them, we ostracize them, we bully them, especially from the warm safety behind our computer screens. We essentially have become no better, in fact we're worse because we're old enough to know better, than that horrible school-yard bully no one liked.

Such behaviour, whether it comes from a politician or a private citizen smacks of a person who has no real position or argument. We're focusing on the wrong things here. Let's just go back to kindergarten for a moment, because it seems we all have forgotten a few golden rules:

1. Name calling hurts feelings and isn't nice, you shouldn't do it;
2. Don't pick on those who can't defend themselves;
3. Treat people how you wish to be treated (unless you're Christie Brinkley circa 1986, maybe you needn't be making fun of someone else's appearance, regardless of what side of the isle you're on, just sayin'); and
4. If you have no idea what you're talking about, don't talk. Remember the old saying, "better to stay silent and be thought a fool than to speak and remove all doubt?" it's good advice, consider taking it.

And while we're at it, let's try something fun and new, or really, not so new. Let's try going back to what we called a civil society. You know, where we could all hold different opinions and beliefs and debate and discuss them, and at the end of the day, we agreed to disagree, had another beer and called it a day. There's not one of us that has figured out the right way for everything. There are so many problems in the world today, why not stop the insults, the rhetoric and shut up and listen, maybe together, we can get something accomplished. You may not have noticed, you know, because of the blinders you've got on, but, it's getting real out there and it's going to take many different people from many different perspectives to fix it. I won't tell you how I lean politically because, one, it's none of your damn business; if you know me, you know where I sit, and two, at the end of the day, my political leanings or party affiliation doesn't matter, it's just not germane to the discussion.

No wonder only roughly half of us even bother to vote!

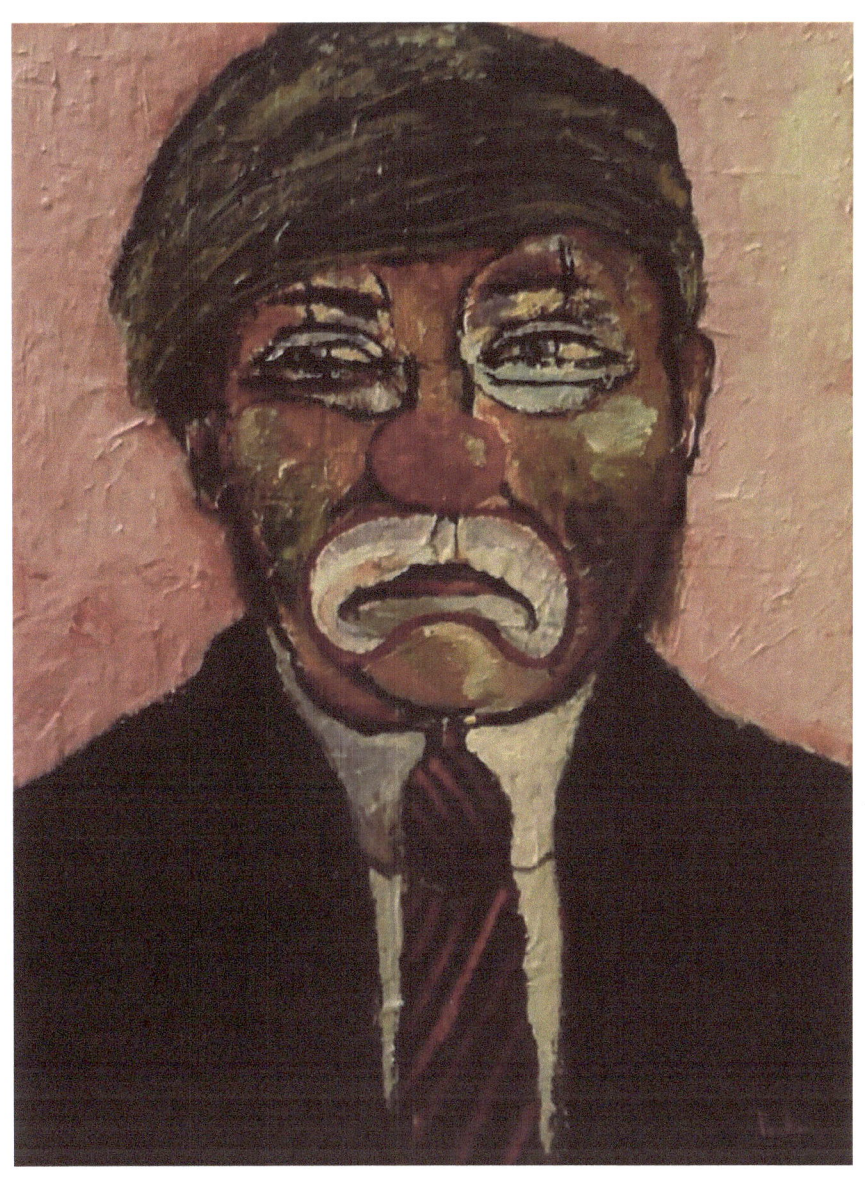

UNDER THE BIG TOP

All the world's a stage and we are merely players, isn't that what William Shakespeare said? Well, if anyone proved that point, I'm going to have to say it was Donald Trump in the 2016 election. Not only was he the guy that got me hooked on American politics, and I suspect he did the same for many others, but let's face it, he surprised us all! Let's break it down, in hindsight, did he really surprise us at all?

Okay, yeah, he was a real estate mogul and a reality television star, and, at first no one took him seriously, but if you look back, he was discussing, publicly, a run for the White House way back in the late 80's. Anyone who says they were surprised is either full of it or hasn't been paying attention.

If you think he didn't calculate the right time to enter the race, to feel the pulse of middle America and then jump in, you're delusional. He did. Do I think he sincerely cared about his nation and wanted to get in and do something, yes. No person in their right mind is going to spend millions of dollars in the hope of being chosen to do a job for less pay (free in his case) and subject himself, and his family to constant ridicule and scrutiny. Even ego isn't enough of a reason to endure such punishment.

The fact is, the political arena was a circus in 2016, and he was the ring master of all of it.

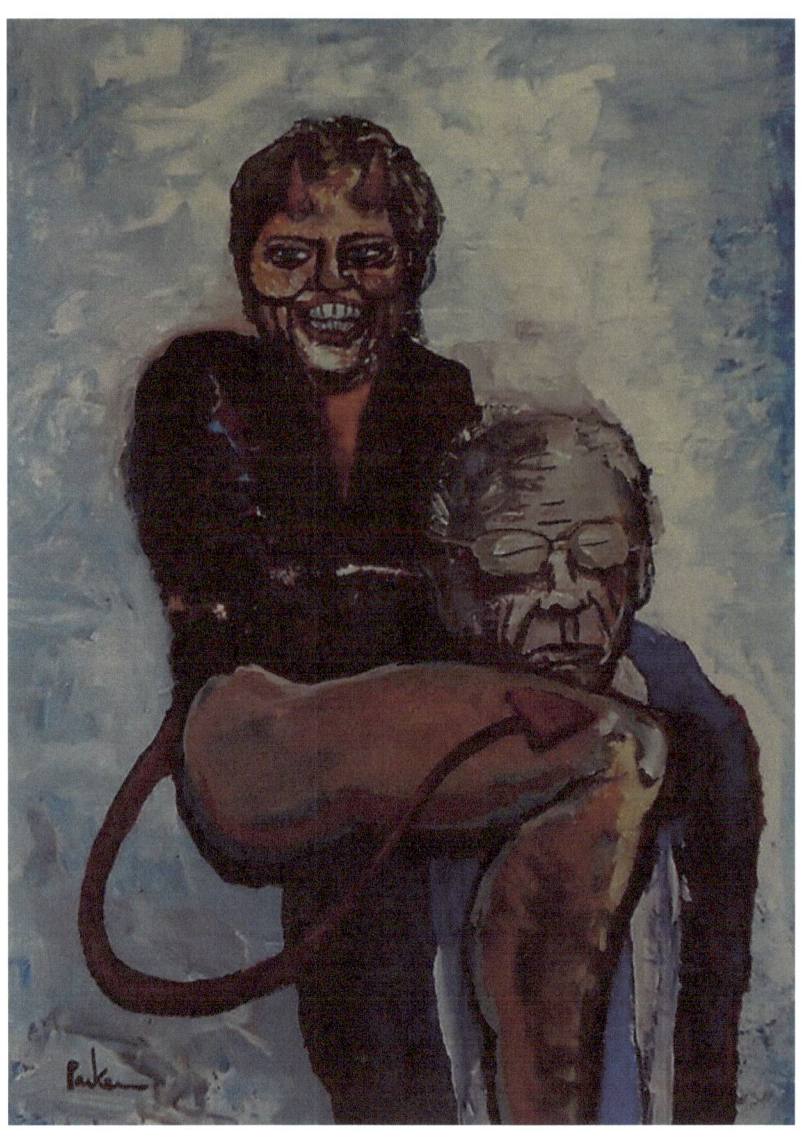

THE DEVIL YOU KNOW

Oh, Hillary, you tried, and you tried. You had your eye on the White House when you were still living in it. Can't blame you, really. I think everyone can agree that you were the brains behind the charismatic Bill. I mean, seriously, if he could be elected twice, surely you can get the nod once, at least. Okay, you lost to Obama, but he was just so damn inspiring. 2016 was your turn, you were all but coronated, you drank the champagne and tasted the thrill of victory. Bill would be the First Husband, perhaps you'd take a lover of your own, or not, but the possibility had to have made you smile. No one would've blamed you. Heck, most of us would have applauded you and cried "just desserts". We were with you then, we understood how complicated it was to be with a man that liked to participate in extra-curricular activities. And we sympathised and emphasized with you at the indignity of having your private problems being made public.

We were also with you when the media made fun of your daughter during her awkward phase. Kids and wives are off limits to me, and the person who wasn't awkward at 12 or 13, well I'd love to meet them.

.

But you lost us, you miscalculated, didn't you? You never dreamed that times had changed, it wasn't the 1990's anymore. The youth of your party wanted something different; they wanted democratic socialism brought to them in the comforting package of a secular Jewish grandpa type; that European free education and free healthcare for all was too sexy to pass up. Poor kids, they have no idea, it just sounds so good. I bet you told yourself you had to do it, you had to neutralize him; I mean this was your dream, and let's face it, time wasn't on your side.

This was the last, Hail Mary, now or never bid for the big prize. You won the battle, but at the end of the day, you still lost the war, again miscalculating the pulse of the nation and the decade you were in. Slick career politicians from Washington and New York were out, and plain-speaking middle America was in. You were bested at what you thought was your own game by a reality television star who flipped the game on its head and made it his own. I wish I could say I hate to say it, but I don't, you got cocky and it cost you bigtime. Karma for the DNC screwing Bernie over behind the scenes? Perhaps, if one believes in such a thing.

And now, you're left with what... regrets of what could have been, the odd opportunity to comment on political matters? My advice, you tried, it just wasn't meant to be. Enjoy your golden years and find peace with your lovely daughter and your grandchildren. I'll bet you're a kick ass grannie. Retired life isn't so bad. So, you didn't create the legacy you had in mind, that's politics, now isn't it.

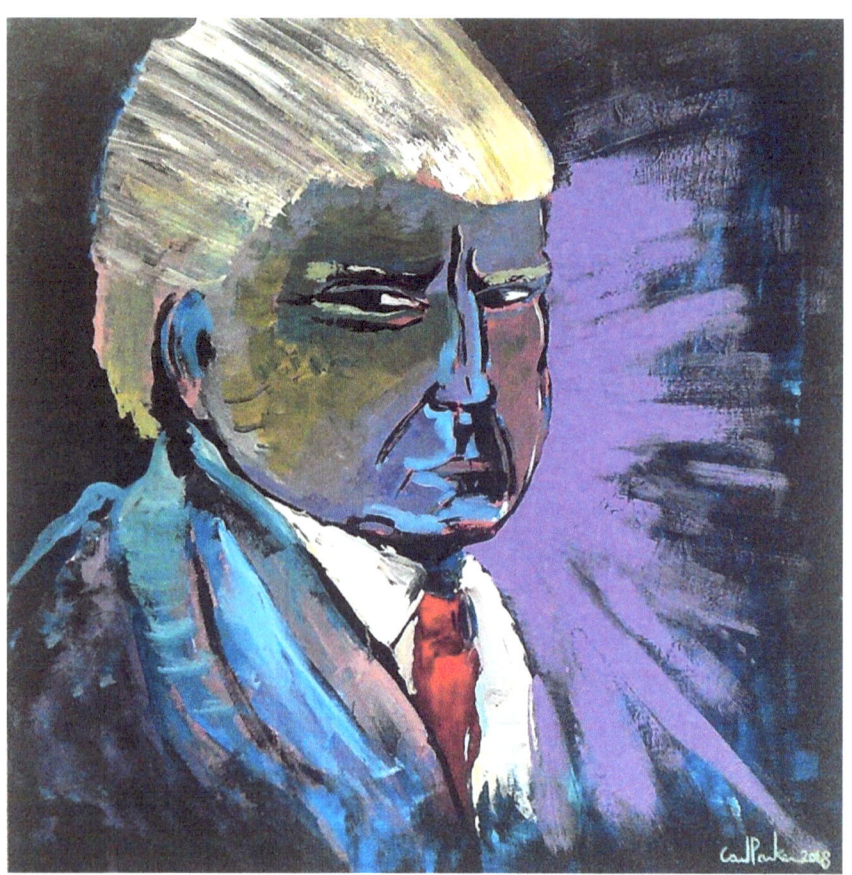

WELCOME TO THE EVIL OFFICE

I completed this piece as a response to the anti-Trump rhetoric that was everywhere. This was smack in the middle of the migrant crisis.

Granted, as an outsider, what can I say? I won't lie, I admired him in some respects because he was a politician that finally did that one unprecedented thing, tried to carry out his promises. I do like a person who keeps true to their word. He lowered taxes and brought back some jobs and went to North Korea to try to achieve at least some small steps toward peace on the Korean Peninsula.

Then there's the wall, well, it seemed he meant what he said there too. Then we started seeing pics of poor little sick kids at the border, in cages no less, cages! Children screaming, sobbing. This isn't something we tolerate as a civilized society! Was it the media, and his political opponents spinning things, or was Orange Man bad, was he in fact, evil? Did he really hate children and immigrants? Social media had already condemned him, and this piece captures that moment. I guess time and history will determine his legacy in the end.

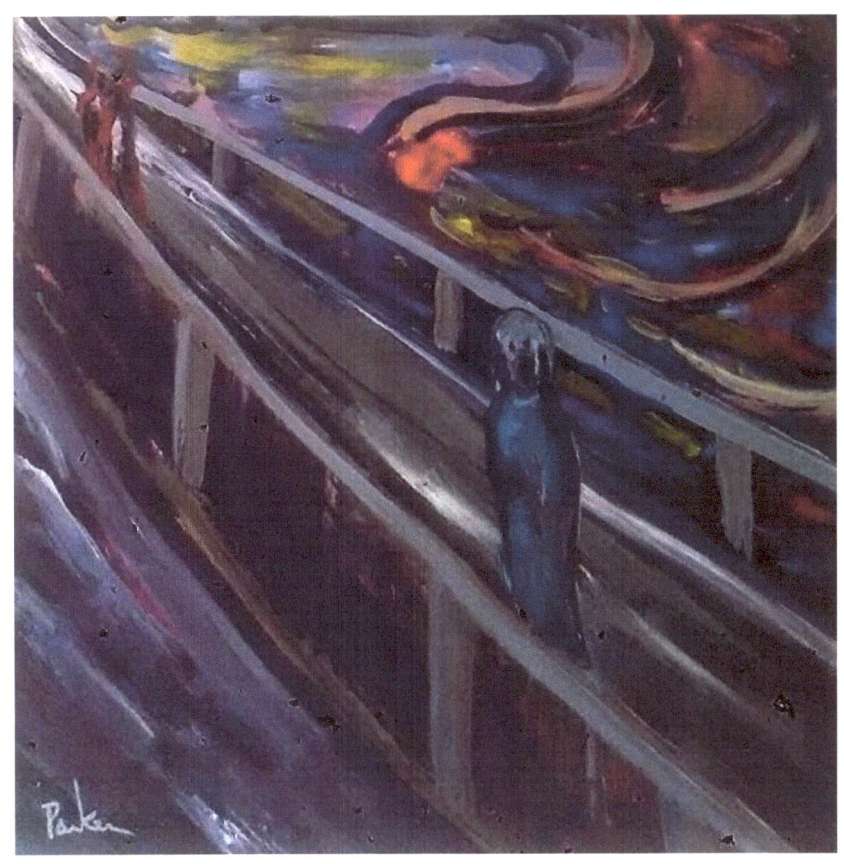

POLITICKS

Seriously, couldn't you just scream sometimes when you're reading the newspaper or watching television? Get it? Scream? This piece is very new, so new, in fact that it barely made it into the book. It's obviously inspired by the famous painting by Edvard Munch, The Scream. I call it Politicks because that's pretty much how I view the politicians of the day, like little ticks, jumping to and fro, with no real direction or platform. They're just hopping up and down, not really sure what's going on and what to do about it.

Just look around, a Brexit deal that had been, until recently, negotiated by a Prime Minister who never wanted to leave the EU in the first place. I mean come on. Then, in my own country, a Prime Minister who doesn't seem to know which way the wind is blowing, but when he figures it out, his platform invariably follows that wind.

Then, of course, there's the upcoming U.S. election. It's already shaping up to be a shitshow and it hasn't really started yet! The Democratic Party is chock full of "has beens" and "never heard ofs" all vying for a chance to take on the President. Heck, even Bernie Sanders, who's practically geriatric at this point, is back to take another run. Regardless of your political leanings, you gotta admire the guy's fortitude. If it were me, I'd have told the Democratic Party to take a flying leap after what they did to him last time around, but that's just

me. Then, there's good old Joe Biden, Obama's Vice President, who is arguably more famous for his gaffs and for being a bit "handsy with the ladies" than for the office he held. The field is rounded out by a bunch of supporting players, because let's face it, the real race on the Democratic side is Bernie vs Joe.

As of now, we don't know who will dare take The Donald (can we still call him that?) on for the Republican nod. The 2020 election is shaping up to be the best reality television that ever graced the small screen!

Observing all this from the outside, it appears common sense is to be swirling over heads of these politicians, just high enough that that can't see or reach it, and we, the general public stand on the bridge in horror wondering what the hell happened.

But don't sit around pondering for too long, remember, there are always cow farts and tweeting to worry about.

NO SO FREE SPEECH

I'm just a painter, I'm certainly no constitutional scholar, but I always thought free expression was held as a sacred and self-evident right in Western democracies. I remember hearing people say, over and over again, when I was young, "I may not agree with what you say, but I'll defend your right to say it." I haven't heard that in a while.

What happened? Last I checked, the legal documents guaranteeing these rights hadn't been changed, no one I know of has officially revoked them, yet it's pretty obvious you can't just "speak your mind". Holding, or expressing the wrong opinion these days not only holds one up to ridicule and abuse, it reduces the holder to the status of social pariah and can get them banned from any number of social media sites. Say the wrong thing, support the wrong candidate and you run the risk of not only being called names, but to losing friends. This trend of punishing people for "wrong think" and "wrong speak" is disturbing. In fact, it's downright scary and we should be standing together against it. The paintings in this section are my small way of doing just that.

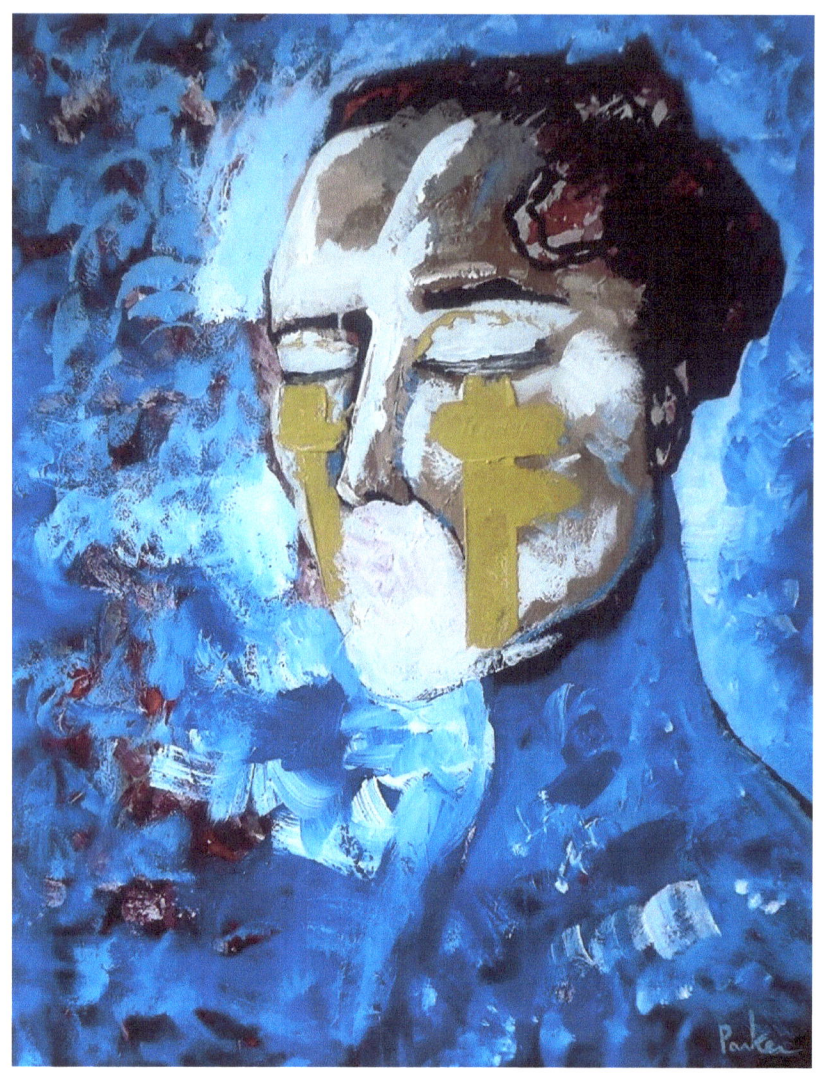

NO NEED TO SPEAK

I've been told that to paint a figure without a mouth, or with a mouth that's covered, is offensive, that it somehow implies that the person in the painting has no voice. Well, good, be offended, you should be.

There's an odd trend I've noticed in recent years in any heated discourse, political or otherwise. It's the trump card that, well, trumps all, every argument, all logic, all reason, and even wins you the verbal joust when you're absolutely one hundred percent wrong – being offended.

I'm not sure when this happened, but I'm telling you it works every time. Losing an argument, cry offence. Disagree with someone, cry offense. It leaves your opponent in stunned silence, paralyzed with the fear of "being offensive." I mean most of us don't want to hurt another's feelings and will naturally try to avoid doing so and as a result, hearing that your words offended someone is particularly jarring.

Well, "no offence," but "I'm offended" isn't a position, it isn't an argument, it isn't anything. Yet when faced with hearing something you don't like, it proves to be more powerful than Superman's Kryptonite, there's no need to speak, just be offended, hence the name of the painting.

Well, you know what? THAT offends me!

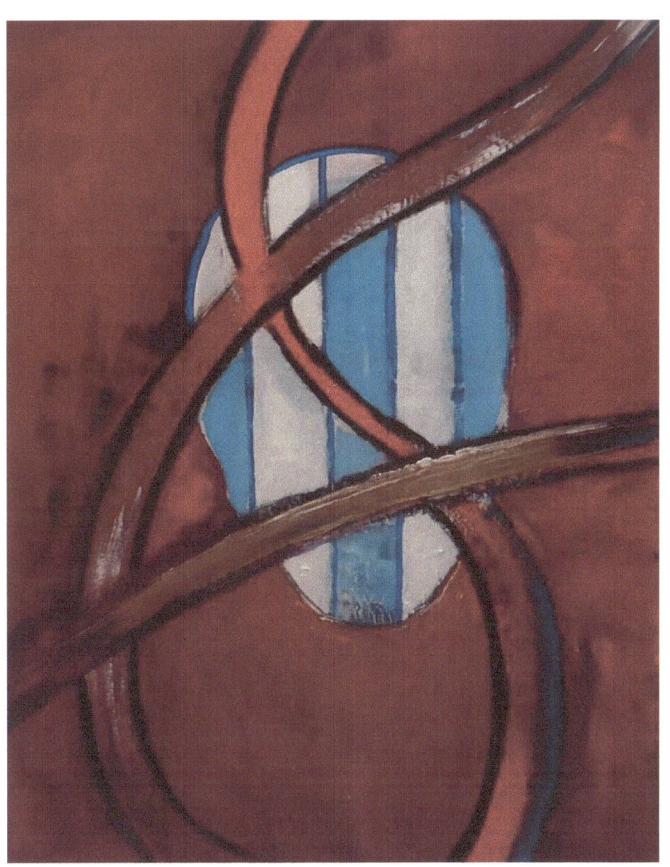

SILENCE

This piece is another one of my favourites. I had a lot of fun painting it. It's called Silence because that seems to be the name of the game now, do whatever it takes to silence any opposing view to your own. The tactic is very similar to the "that's offensive" strategy I spoke of previously, but it's harsher, meaner, more pointed. The colours I chose are for obvious reasons, I mean nothing spells freedom like red, white and blue; ironic isn't it? And the ribbons, ropes or whatever they are, covering and wrapping themselves around the faceless face represents the silencing technique I'm speaking of. You know the one, it happens when you not only accuse a person who holds a view opposite to yours of being offensive, you take it a step further and accuse them of all sorts of heinous things. You see it every day and it's incredibly powerful and so simple. Just think of the worst possible thing you can call a person and accuse them of that. It works every time. I mean, who wants to be accused of being a terrible human being? The danger with this type of tactic is it eliminates any possibility for discussion. The free exchange of ideas that we so pride ourselves on becomes chilled to the point that no one dare go against the popular opinion of the day for fear of these nasty allegations. When you control speech, you control entire populations and that control can have drastic and dire consequences, like, well, let's see … anyone remember some nasty business

over in Germany back in the 1940's that hardly anyone dared speak up against? No one has the market on the right way to do things cornered. We need to get over this fear of differing viewpoints and get back to respecting each other's opinions and dare I say, listening. Hey, you never know, we may even learn something.

And if that doesn't convince you, just look how utterly stupid this method of squashing opposition looks when you see it in print. Opposed to gun control, you must hate children and want them to be shot. In favour of border security, clearly, you're a racist and probably a fascist, to boot. Support the right, well, you're a woman hater and obviously homophobic, and probably a hillbilly. Support the left, well, obviously you're a communist and you hate middle class working America; your hair is probably pink. Can't mount a cogent argument so you resort to this tactic, you're an idiot. Offended? See above.

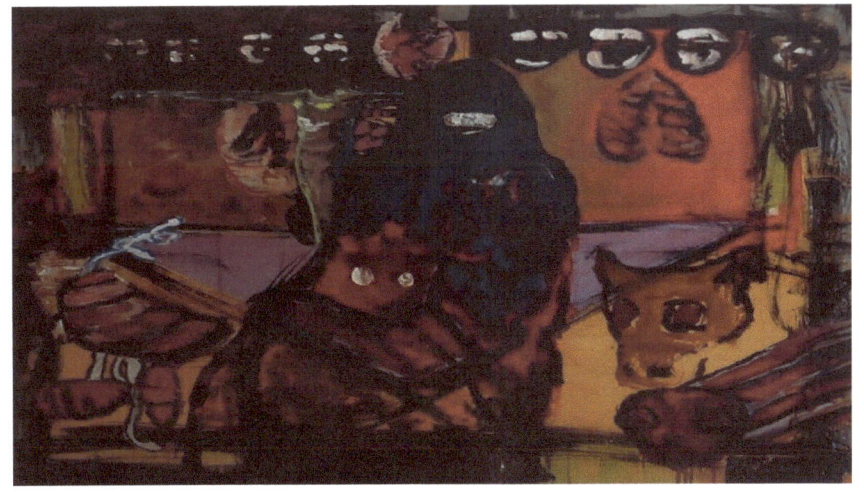

TODAY'S MENU

Scary and dark, isn't it? This was one of my very first protest pieces and while it's not completely about free speech or the lack of it, it does touch on it. I called it Today's Menu because it represents a critical look at what the media serves up to us on a daily basis, and how those sound bites and headlines tend to be crafted in a way to make us think in a certain way. Sometimes, it's an us against them type of thing, like when they show quick shots of people in Arab countries yelling, screaming and causing chaos rather than sitting quietly and having a coffee. Or maybe it's the Republican from the trailer park with no teeth and even less education. Those visual cues are very powerful and are tough to resist, even among the more intelligent among us because they quietly seep into our minds and just lay there, undetected until suddenly, we're expressing the very viewpoint they were intended to elicit. It's done with the print media as well, so don't think you're immune because you claim not to watch television. Sometimes the way something's said is more powerful than what's said. For example, "XYZ Candidate Wins Minority Government," is quite different than "XYZ Candidate Fails to Score a Majority Government." One has the reader believing the candidate is a winner while the other suggests he or she has failed miserably. Don't drink the Kool-Aid, kids, do your own thinking.

GENERAL SOCIETAL TRENDS

This section focuses on the general trends I've observed in today's society that drive me absolutely nuts! I don't think there's been a day that's gone by in the last few years where I haven't just shook my head, whether it's the complete and utter lack of personal responsibility people accept, body shaming, glorifying stupidity, political correctness, or some other such nonsense, if it's annoyed me enough, I've painted it.

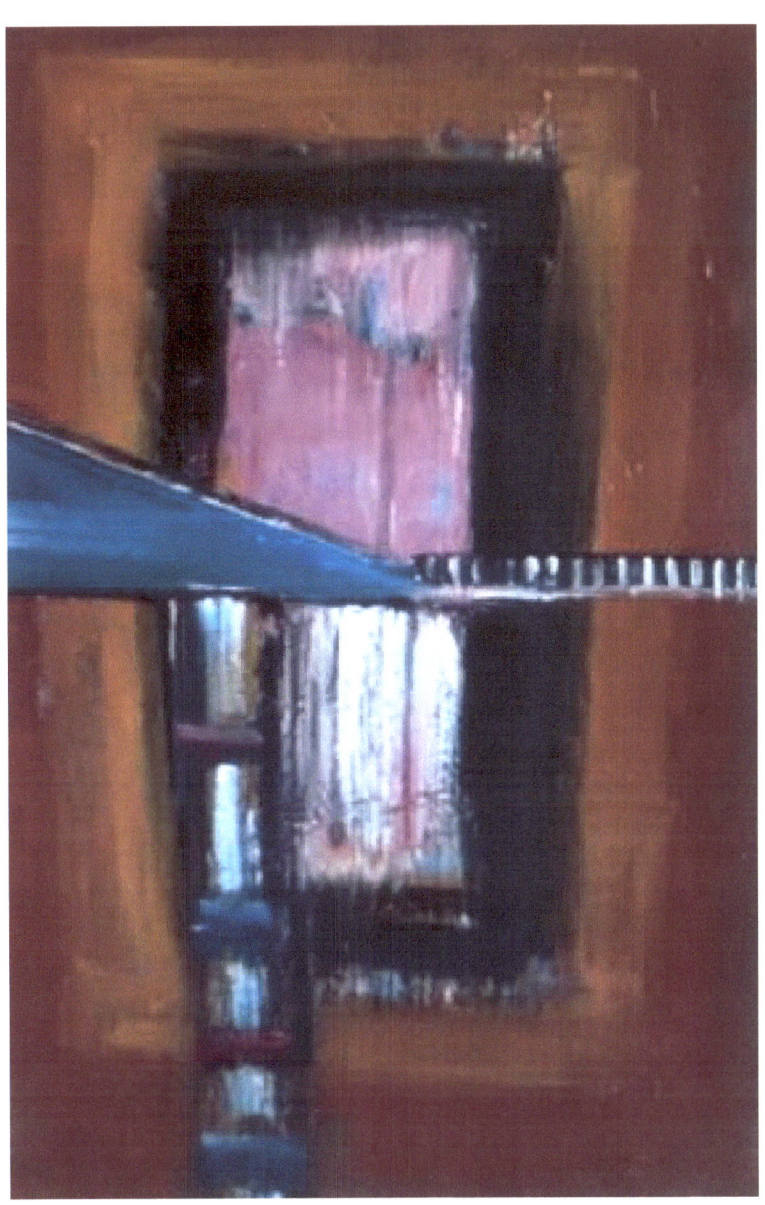

ROAD TO NOWHERE

Have you noticed that we, as a society, have become offended by everything? And I mean literally EVERY FREAKIN' THING! Holiday cartoons that have been on for over 50 years, Christmas songs, words, names, titles, opinions, political leanings, you name it, someone's offended. And if someone's offended, you better believe, the world is going to hear about it, loudly and often! It doesn't seem to matter what it is, or what side of whatever you're coming at it from, someone is complaining about something.

Granted, there are things worthy of complaint, and calling attention to those things, I get. But it seems nowadays, there are just constant complaints, constant hurt feelings, constant critiques, mostly about mundane things that simply don't matter, without anything else. What ever happened to, you know, doing something about whatever you think is wrong? If you're spending all this time and energy complaining, it seems reasonable to me that some of that could be directed toward finding a solution.

We're finding things to complain about, to be outraged over, where no such affront exists. I believe the official term for this phenomenon is manufactured outrage. And that's why we're

not wasting any energy of coming up with solutions to these so-called affronts, there's nothing wrong, there's nothing to fix. Are we really that bored, or better yet that boring that this is what humanity has devolved into, a constant search for and identification of things that offend us just so we can be noticed or have something to talk about? Evidently, and that's why this piece was aptly named Road to Nowhere because that's exactly where all this ridiculous outrage is taking us.

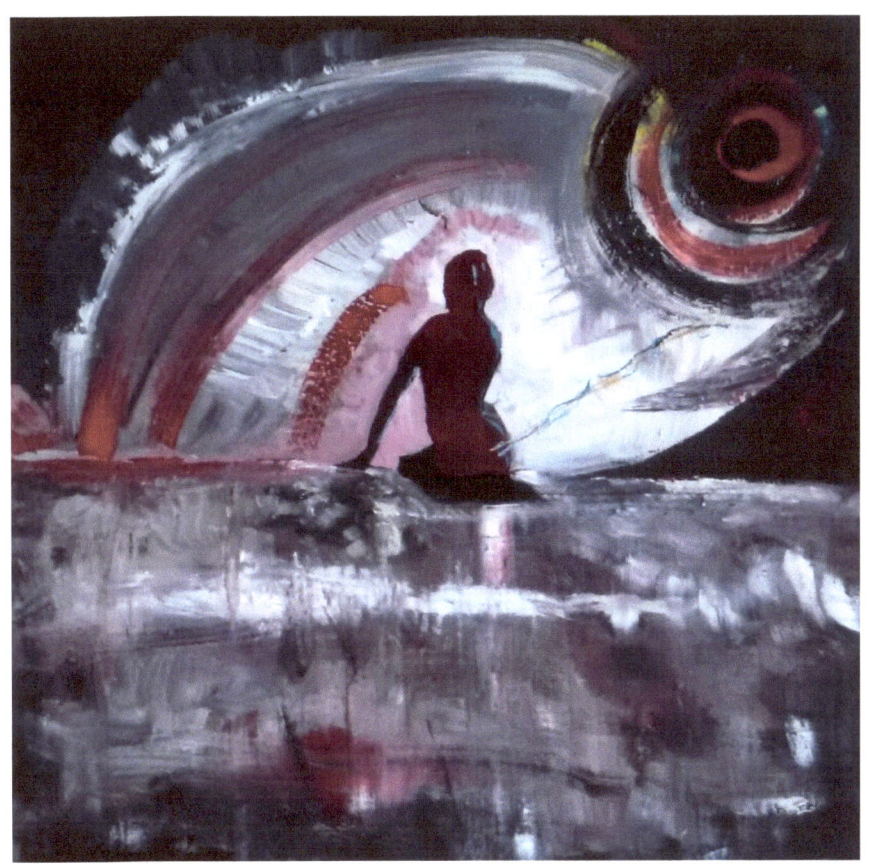

SELF MADE

If I had to choose just one thing that really grinds my gears, it would have to be people refusing to take responsibility for their actions, their lives and everything else in between. That's what this piece is about. We've all seen these people, they whine and complain about how hard done by they are, how life dealt them a crappy hand. It seems that almost everyone you meet these days has some sort of sob story. But did life really do them wrong? Did life really do any of us wrong? I mean sure, there are those things that come out of the blue, illness, accidents, disasters that wreak havoc on our lives, but come on, such instances are few and far between.

The truth is, much of this so-called misery we're experiencing has been created by none other than, you guessed it, ourselves. We cry poor, yet we're wealthier than 90 percent of the world and have likely spent more on pizza, beer and coffee this week than some people in our very neighbourhoods have available to them to feed their children for the entire month. We complain about our weight while we sit in a state of the art, massaging, reclining easy chairs, eating Doritos, and not just a few, the entire bag! We scowl with envy about the nice things others have, chalking their good fortune up to luck or greed, wrapping ourselves in the comfortable cloak of the moral superiority of our own perceived poverty.

And all these complaints are followed, more often than not, by these three words, it's no my fault. It's not my fault I'm broke, life's expensive and jobs are hard to come by. It's not my fault I'm fat, it's genetic. It's not my fault I don't have a fancy car like that other guy, you know, I've heard he's a con artist anyway.

The fact is, personal responsibility has flown right out the window and is nowhere to be found. Nothing is anybody's fault anymore, blame the parents, blame the schools, blame society, blame the economy, blame genetics, blame the government; as long as the finger never points back in your direction, blame anyone and anything you can, because clearly none of it could ever possibly be "your own fault," now could it?

In this painting, the figure sitting there is sitting in her own hell, the hell she created for herself. However, you'll notice there is a lot of light surrounding her; that light represents where she can be headed, to something better. All she has to do is stop complaining, take a good hard look inside herself, take responsibility for the things she can change, and when she does, she'll begin inching ever so closer to that light. I'm not saying it's easy, in fact it's very difficult. I've had to do it several times in my life and it was awful while I was going through it. And there are no magic pills, no quick fixes. No matter what you think, or think you've been told, there aren't any shortcuts. Sitting around manifesting isn't going to do it for you; the secret in The Secret, and if you were paying attention, they did tell you this, is to get off your butt, accept responsibility and take positive steps toward your goal. The second you turn that finger back around at yourself, is the first second of the rest of your life.

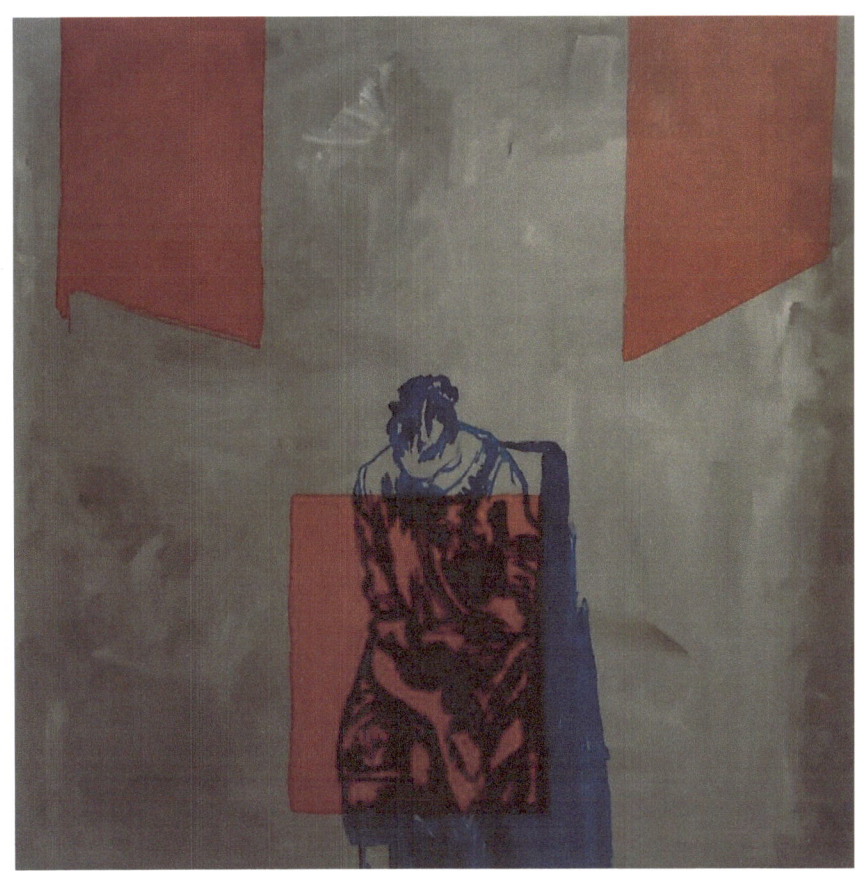

THINK

The power of this piece is its simplicity as is the power of the message it conveys. Most days, I find myself wondering, do people even think anymore? I'm pretty sure they "think" they do, I hear them saying, "I think" this and "I think" that, but more often than not, they're simply parroting something they've heard or watched, often in the same words the so-called thought was presented to them originally. It's very easy to determine whether one is actually thinking or simply reciting, just ask a follow up question. If the response is, "well, so and so said," or "well, I saw," or "I read", and it invariably will be, that person isn't thinking.

Now when I say thinking, I mean critical thinking. Remember critical thinking? It was a skill they kept wanting us to develop in school all those years ago. It's the ability to objectively analyze a given issue in order to come to a judgment or conclusion. It's not swallowing what some news network, your boss, your neighbour or some holy text tells you. It's dispensing with the herd mentality and weighing things in our own mind, considering whether it accords with common sense, truth and the remainder of our body of knowledge and forming our own opinion. We really need to get back to that, I mean we're not sheep, we're just acting like them.

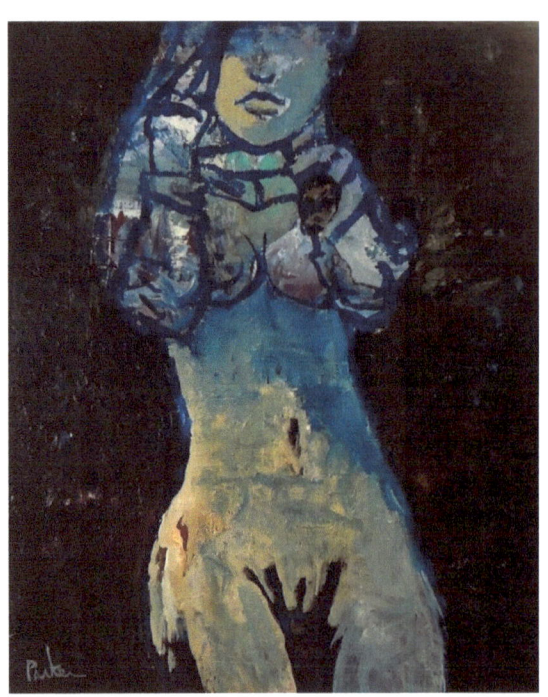

BLUE GIRL

This painting is my commentary, and perhaps my big "screw you," to body shaming, in all its forms. I know you're wondering what a painting of a thin, shapely, attractive woman has to do with body shaming, and my response is it has everything to do with it.

People come in all shapes and sizes. Short, tall, fat, thin and somewhere in between and I think we've come at least far enough as a society to agree that the container the person comes in is no measure of the quality of the individual. I myself, am overweight. I'm aware of it, I'm not ashamed of it. I like how I look and who I am despite knowing its time to shed a few pounds.

We've become somewhat more accepting of the variety of forms we come in as a society and advertisers are often using models who are heavier, older and perhaps not as classically beautiful as they once would have. That's a wonderful thing. I mean, they do say that there are more larger people than there are smaller ones, at least in many Western nations, so the people hired to convince us to buy things should look like us, I can accept that.

And it's become, thankfully, unacceptable to make fun of those who are large or not blessed with objective beauty. It's completely wrong to do so and it's completely wrong to make judgments about a person based solely on their

personal appearance. Not all big people are lazy or unhealthy, and not all thin folks have eating disorders or are weak or sickly. The problem is, and I have seen this first-hand over and over again, that somewhere on the way to body positivity and acceptance, we took a wrong turn. Some of us forgot that there still are smaller, thinner people walking among us. And there are classically attractive, downright drop-dead gorgeous people out there too. We may not see them every day, but they do indeed exist.

And we forgot that these people also have feelings, feelings that are hurt when they're judged or made fun of. Calling oneself a "real woman" because you wear something larger than a size 10 is just as demeaning to that girl who wears a size 2 as that bitch in high school that told you to put down the chips. Those cute harmless memes you see all over social media proudly showing a chubby woman smiling and proclaiming such sentiments as "Real Men Want Meat, Dogs Want Bones," well, they're not very nice, are they? Sure, it might not be intended to be hurtful, I know it's supposed to be uplifting, but it's just never okay to lift yourself up by stepping on someone else. Never.

That pretty girl might just be the nicest person you'll ever meet, not a bitch, not a snob, not a moron, but a smart, nice person, and maybe your new best friend. And that really gorgeous guy, well, maybe he isn't a jock and maybe he isn't gay (and if he is, so what). Try getting to know a person before you pass judgment. Remember that old saying, don't judge a book by its cover? Well, if it's good for the chubby goose, it's just as good for the svelte swan.

Body shaming and judgment is just plain wrong in either direction, get that through your heads. This painting is my way of saying so. I've dated big women, small women, cute women, some that weren't what others may have called cute, but they were cute to me. I love women of all shapes and sizes. All of us, men, women, big small, whatever, we're all just dandy the way we are, so let's be kind to each other.

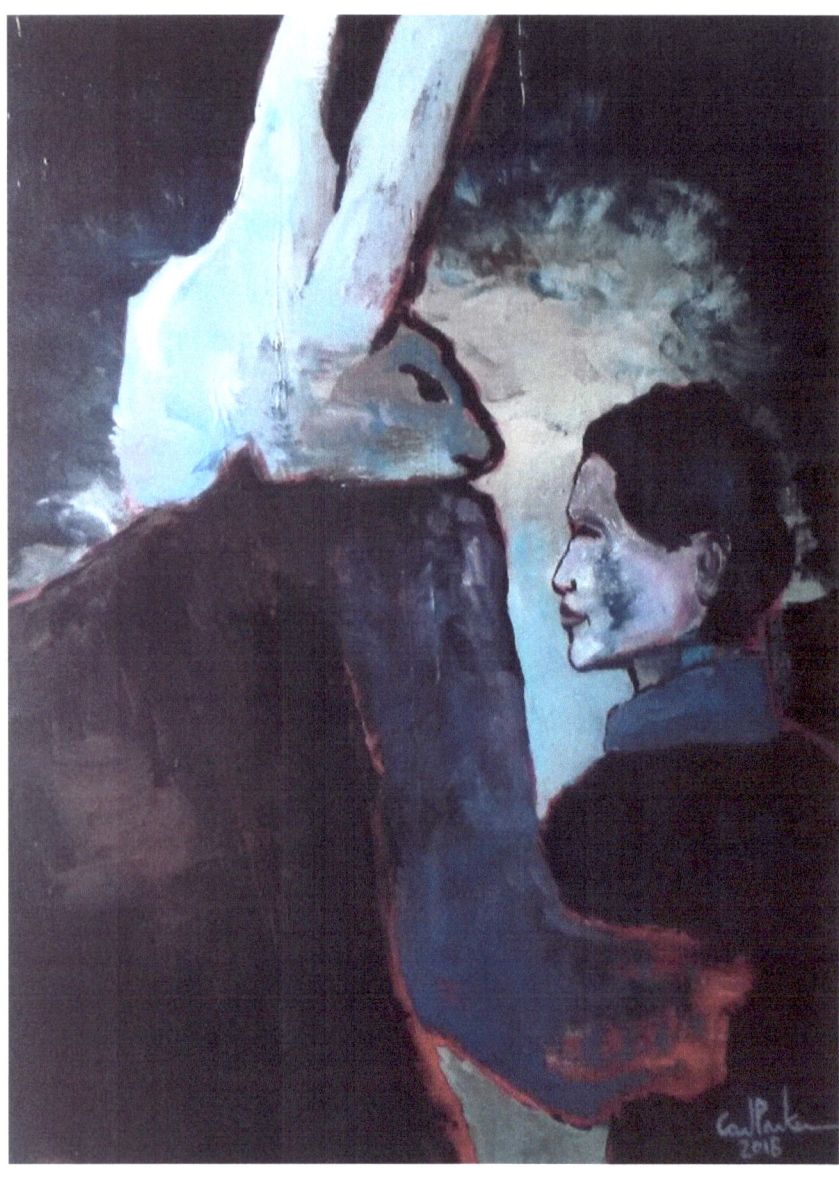

HEADING DOWN THE RABBIT HOLE

I've noticed that in the past few years, say 20, it has become increasingly important to fit in. You must have the right clothes, the right shoes, the right look. You're not getting the ladies? That's because you're not wearing Body Spray X. You're not watching the latest post-apocalyptic drug dealer futuristic whatever show on television? Well, that's it, that's why you feel left out of the water cooler conversation. People rush out to get surgeries to look like celebrities, to get their butts, their boobs, whatever. Newsflash, even those celebrities don't have those attributes, well, they have them, but they paid for them, just like you want to.

Everywhere we turn, someone is telling us what we need, what we need to look like, smell like, what we need to eat, what we need to own, and on and on. Heck, they're even telling us what we need to think. The news, which used to be simply a reporting of the facts surrounding the significant events of the day has become a weird mix of some information with entertainment, all cleverly slanted toward the prevailing popular opinion. I know I've mentioned this before, but it's a big deal and it bears repeating, loudly.

We're so far from the ability to think for ourselves that we've been fooled into thinking that we are.

We follow the bunny, and why not, the bunny is harmless, it's cute and funny and clever, and it's everywhere, until we're so far down the rabbit hole we think that burrow is actually the world! And best of all, following the bunny is easy, no work, no effort, no thought required, just follow along, we all love stuff that's easy, heck, the easier the better. Why grate your own cheese when you can buy it already grated? Why go on a diet or exercise when you can pop a pill? Why waste time and energy forming your own opinions about anything from politics to what type of deodorant you should use when someone will just tell you?

Even those that seek not to conform fall prey to this intoxicating simplicity and fall into lines of their own. They seek out others who also wish to go against the grain. Then, they form a group, and they begin to fall into lockstep, dressing alike, talking alike, etc., conforming to the non-conformity. Anyone see the irony?

 So why is this? Well, to me, it's obvious. This piece is called Heading Down the Rabbit Hole and it explains just that. Humans, as a species, feel the need to group themselves together. We want to be part of the group, to belong, to be "in"; it's an emotional need that feels almost as real as hunger or thirst. Advertisers, the media, they know that, and they play on it, and they do it very well. Remember being a teenager and just having to have that brand of sneakers or you'd "just die"? Well there you go. What's more disturbing now is that this has been extended well beyond products into how we think, how we speak and how we vote. Personal opinions and ethics have somehow become a public matter where daring to express the wrong one holds one up to such ridicule and hatred that we've moved from "just dying" without the cool sneakers, to "just dying" if anyone finds out we think or feel or voted "xyz". Don't believe me? Test it for yourself, next time you're on any type of social media, I double dog dare you to post something positive about President Trump. I don't care if you actually believe it or not, your political leanings aren't the point here. Oh, you can't do that because you'll be jumped on by all your friends and followers, subject to ridicule and instantly labeled a social pariah? Annnnnnnd, there's my point.

We've fully followed the rabbit into the hole, people, and if you look closely, he's not cute, he's not clever, and he's not funny. On the contrary, he's sinister, he's sneaky, and he's dangerous to the very thing that makes us great, our differences.

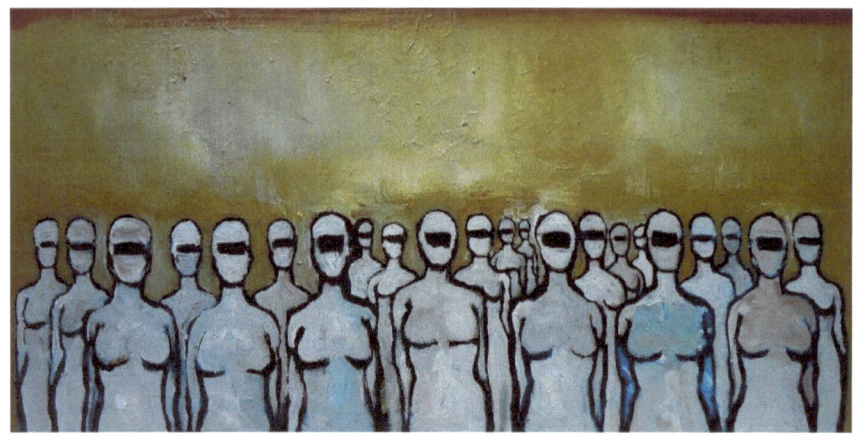

HOMOGINIZED

Although I wouldn't call this a protest piece, per se, I can say that, to my recollection, it is my very first social commentary piece. I completed it in 2014 and it coincides with my political and social awakening, my renaissance, if you will.

The message, along with the title, is likely self-explanatory. It's a statement about our tendency to fall into line, to blend in, and how we're both actively and passively encouraged to do so. It's very similar to Heading Down the Rabbit Hole, but admittedly, at the time I painted this, my frustration, or rather the subject of my frustration, hadn't fully come into focus.

Have you ever noticed that anyone going against the popular opinion of the day is portrayed in a negative light by the media? Probably not but look closely. It really does happen, and it happens a lot. That unpopular politician in the news, he or she seems to have the worst luck with photos, every single one that's published has him or her looking like a deranged lunatic. Those women who support the female candidate can't all be pink haired, squarely built and mad as hell, can they? And are all those opposed to gun control really beer swilling, truck driving rednecks that want guns just so they can shoot vermin? Of course not.

These images are no mistake; they're carefully crafted to create the desired narrative. That unpopular public figure, that voter on the wrong side of the

political divide, those people over there in that other country, see them, they aren't like us, they're undesirable, and you don't want to be like them, right?

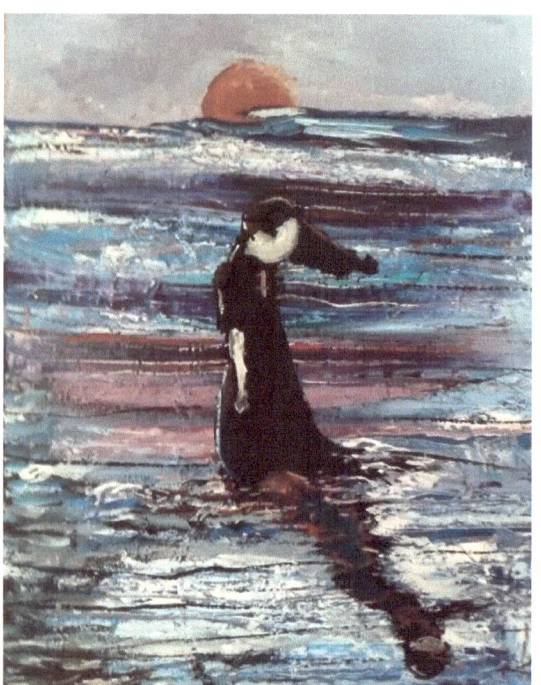

BENEATH A RED SUN

Finally, this piece, it doesn't really represent any particular thing I think is wrong with the world, rather it represents all of them and how I weep for humanity if things don't change soon. Being what feels like the sole voice of reason in a sea of swirling insanity is a solitary, lonely feeling at times. With that in mind if anything I've said or painted here has given you pause, if even for a moment, my work here is done.

www.ingramcontent.com/pod-product-compliance
Lightning Source LLC
Chambersburg PA
CBHW041300180526
45172CB00003B/913